Peter Howson

Harrowing of Hell

24 October – 22 November 2008

The art of Peter Howson is deeply ambitious in thought and deed. He deals passionately with profound personal, social and spiritual themes, using masterly technique to accentuate the positive, exaggerating line and colour, darkness and light, clarity and ambiguity. This is figurative, narrative art in the grand tradition.

The current exhibition marks an expansion of the themes that Howson developed on emerging from inner crisis. Literally poisoned by drink and drugs, he was saved by spiritual discovery. Christianity opened new possibilities for life on earth and the promise of salvation. Howson's relationship with his daughter Lucie, now twenty-two, was a major factor in this recovery; she appears in various guises in all his paintings.

Her diagnosis with Asperger's Syndrome, a condition related to autism, from which her father also suffers, brought him much pain. That has been fed into the potent mix of his art. Howson has always married his personal narrative with a broader concentration on modern life, symbolised early on by Glaswegian whores, football louts, night clubs and much near-caricature; work as official war artist in Bosnia led to an unforgettable series on the horrors of modern mini-wars; a reworking of the *Rake's Progress* charted personal disintegration within a collapsing society.

These earlier Howsonian motifs have blended into the spiritual struggles to make religious preoccupation the driving force of his latest work. The four large paintings in this show are an anthology of Howson's latter-day expressionism. In *The Everlasting Man* (the title of a G.K.Chesterton book on Christianity) Howson depicts the Crucifixion with all the pain and power that emerged from fervent medieval imaginations in the first sacred art.

The artist's own pictorial vocabulary adds to the mystery - like the small house with a round window, which is one recurrent and unexplained image. Elements near the dying Christ recall earlier works in which a seedy nightclub features a single figure who is surrounded by a sinister, menacing crowd. Here the medieval soldiers in the foreground mingle with modern navvies. The whole canvas throbs with barbarity — witness the ape-like creatures high on the ruined wall. And there are more personal allusions — the crouching foreground female is surely Lucie.

The same figure appears in *City of Destruction*, a title gleaned from Bunyan's *Pilgrim's Progress*. The work recalls some of the Glasgow paintings with its tight composition of powerful bodies charging across the canvas. Howson uses erotic motifs of female bodies, wholly nude or semi-bare. The background is urban destruction, and the actors seem terrorised. Yet their objective is a land of blazing light, a paradise that suggests William Blake. Other elements recall Lucie Howson and the artist's anxieties for his daughter.

The Blake-like sky shrinks to a mere hole in the clouds in *Landlord's Castle,* another rush towards the light. The title is taken from a sardonic refrain ('When an Englishman's house is the mighty landlord's castle'). The hounds of Hell lead the charge, and the entrapped, protesting girl cannot escape from the prophetic non-stop leader. The mostly grey painting invokes horror; Howson knows the hardness of the road from sin to redemption, from desperation to religious hope.

With *Harrowing of Hell,* we are in the world as seen by a Hieronymus Bosch or Matthias Grunewald, and no mistake. Howson has a phenomenal ability to take a large canvas and fill it with figures, most of them as vivid and alive as film extras caught in close-up. As in *The Everlasting Man,* the central figure is the crucified Christ. This is the moment when the body is pierced — in this version, by a lance.

The killer immediately suggests Don Quixote. This astonishing work abounds with allusions, many to Howson himself. The title refers to the descent of the executed Jesus to free the incarcerated victims of Hell. The composition is built round the small, central, illuminated figure of Christ, in crucifixion posture, but no longer on the Cross. Howson also lights the forked staircase, which on the left presumably rises to Heaven: the stairs fork, and the right-hand fork has a sinister red glow at its head.

The assembly of astonishing and brilliantly grouped portraits includes at bottom right an old man and a young, naked girl. The aged man is surely one of Howson's famous creations — the Dosser. Ragged and ruined, he may be clutching a bottle, but there is alarmed hope in his eyes. The nude, arms tied behind her back, eyes closed, strains towards the light. The turbulent scene is magical in its creation of living humans in this terrifying world: the crowds are dominated by muscular and armed men, including a diving figure bent backwards, and a brute wielding an enormous oar as the passengers struggle and drown in an overcrowded vessel.

Howson has portrayed this Biblical story before in a dramatic narrative of great power. The same strength of Biblical interpretation is strikingly evident in the twenty-nine small drawings which accompany the four large canvases. Howson has been a prodigious drawer from the beginning, and these profound works, with titles such as *Despised, Crucified, Glorified; The Hour has Come;* and *By His Stripes* plumb deep wells of personal feeling about the *King of the Jews.*

All Howson's works, he says, are autobiographical or semi-autobiographical. He sees Lucie's traumatic syndrome as 'a faith test', for in his mind pain and suffering are essential to life. His own emergence from a sometimes excruciating past is a triumph of the will, although he fears lest his grasp on the better life proves to be precarious.

Through his formidable art, however, Howson has found the strength (too strong for some over-fastidious tastes) to create a dramatic, dynamic body of work that draws on the depth of his personal beliefs about life on earth, which he sees in apocalyptic terms. He stands in a long line of masterly artists who similarly found their inspiration in the creation of beauty from ugliness, in reconciling the good that men do with the illness with which it is so often attended.

Robert Heller, London 2008

Paintings

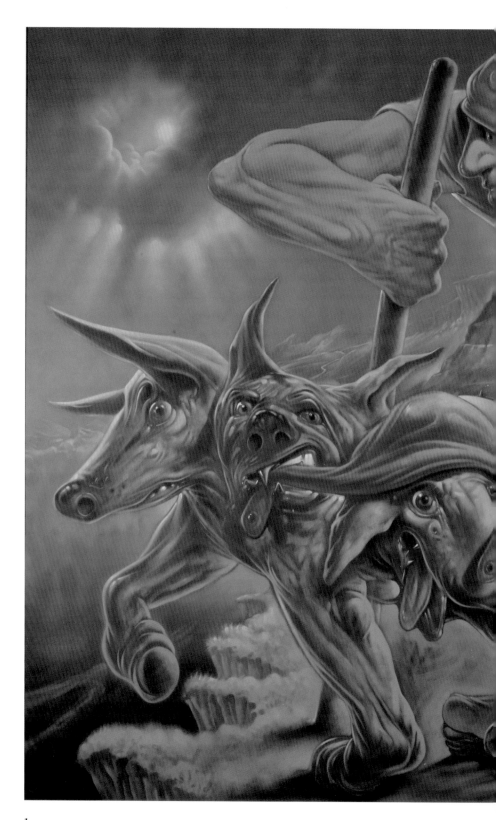

1

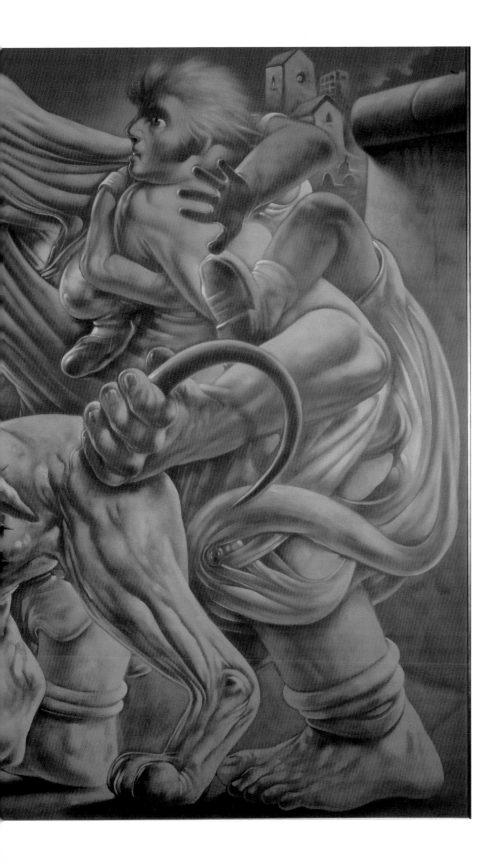

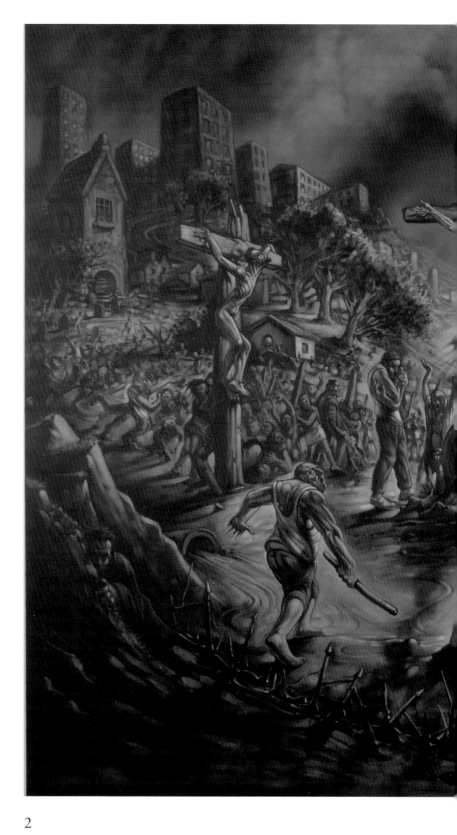

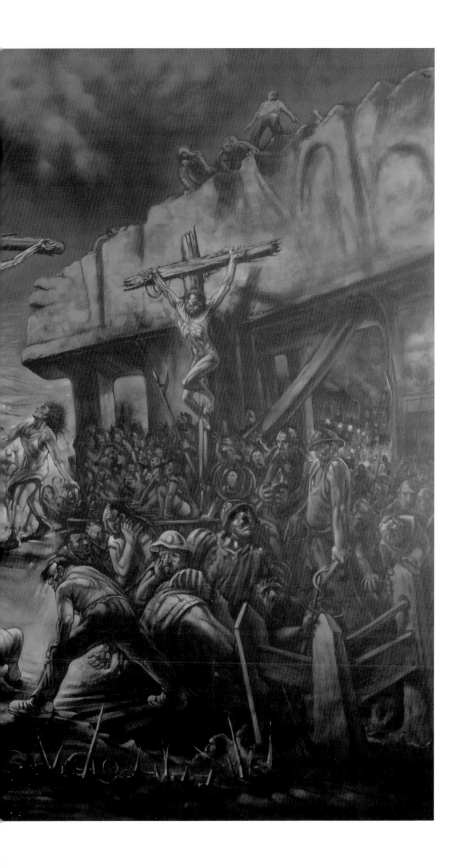

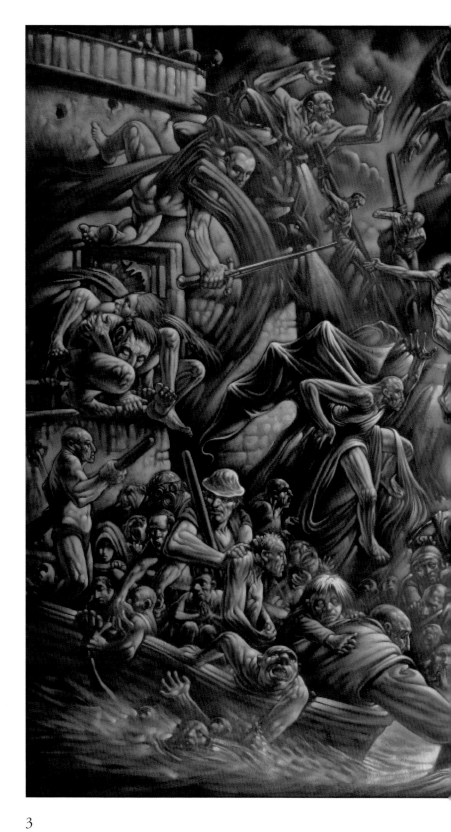

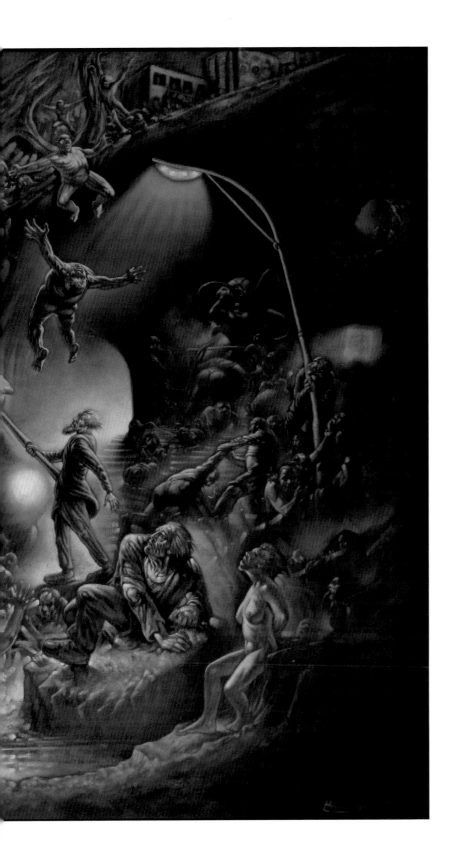

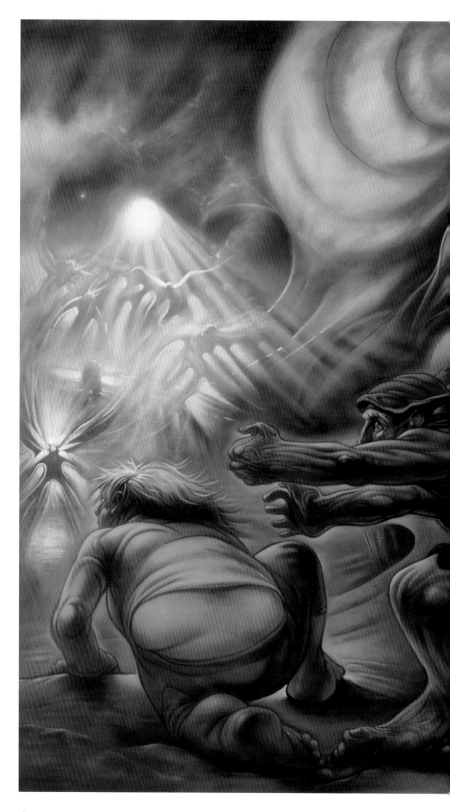

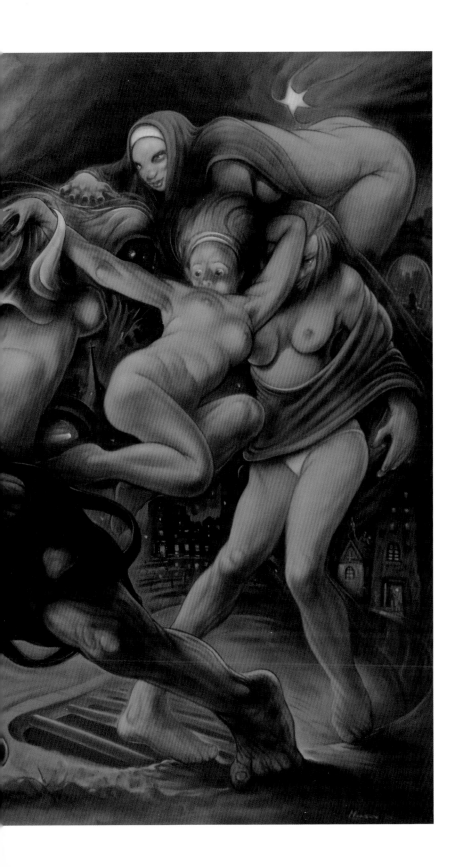

Drawings

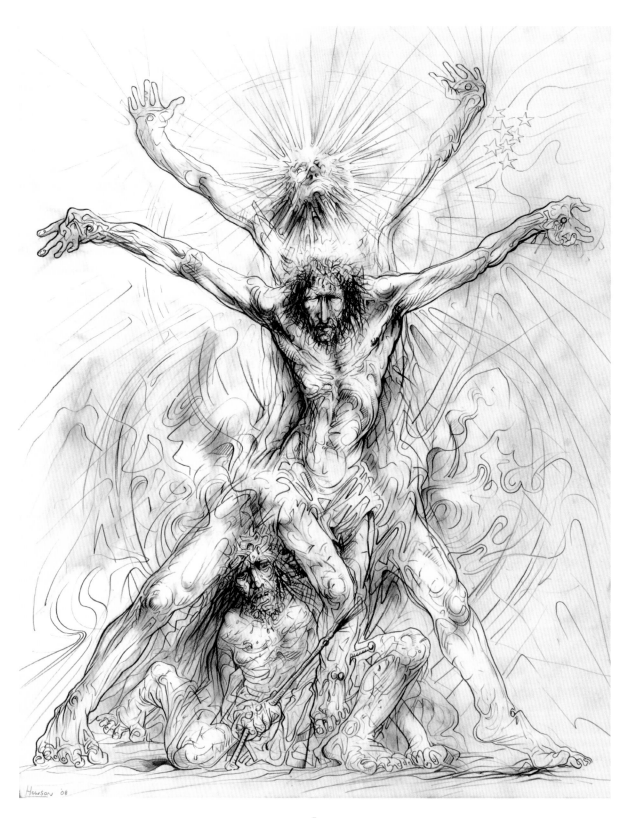

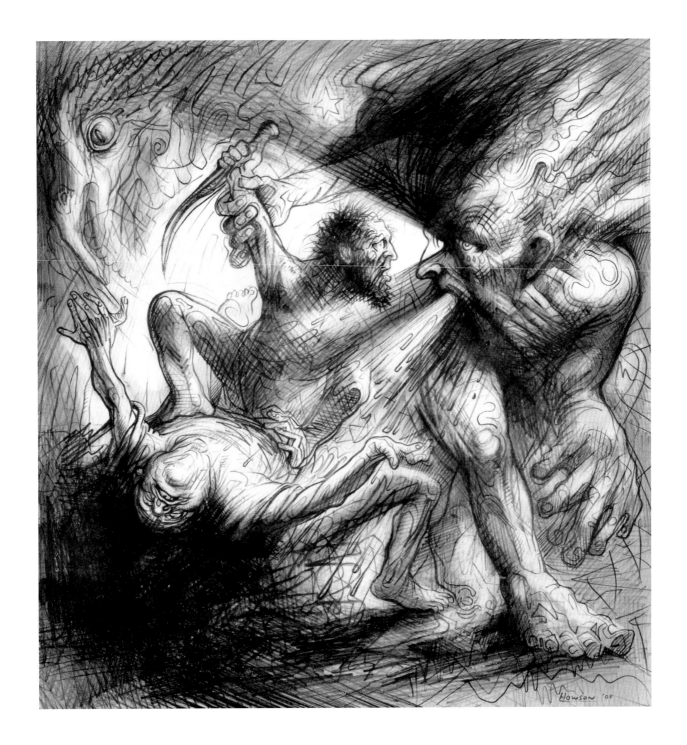

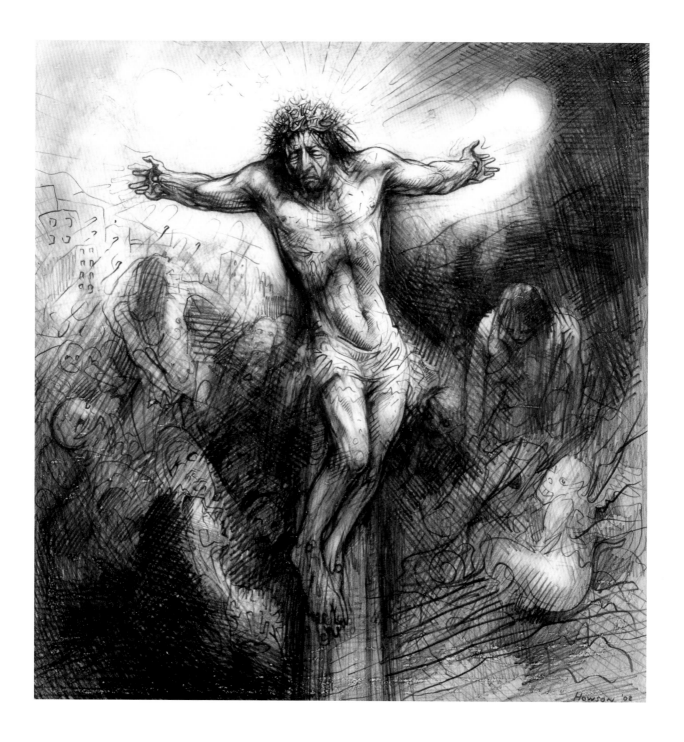

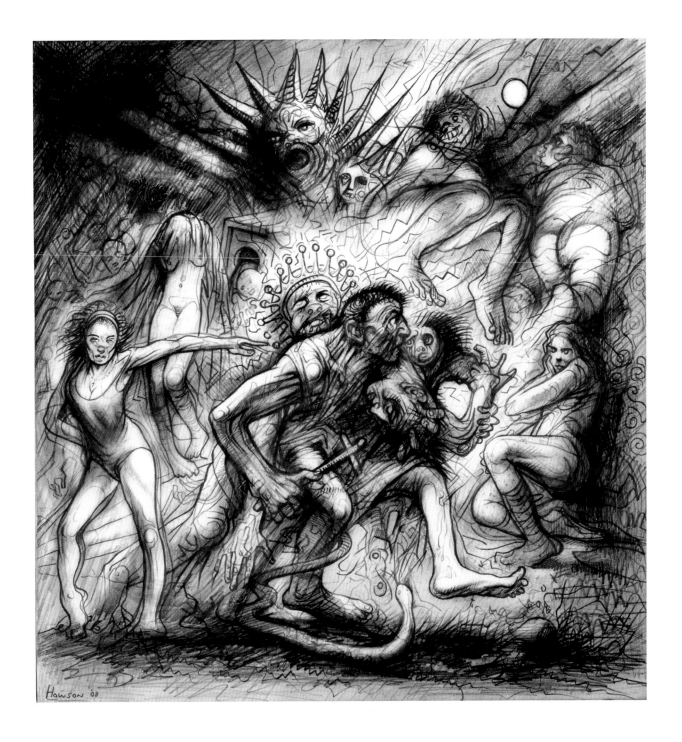

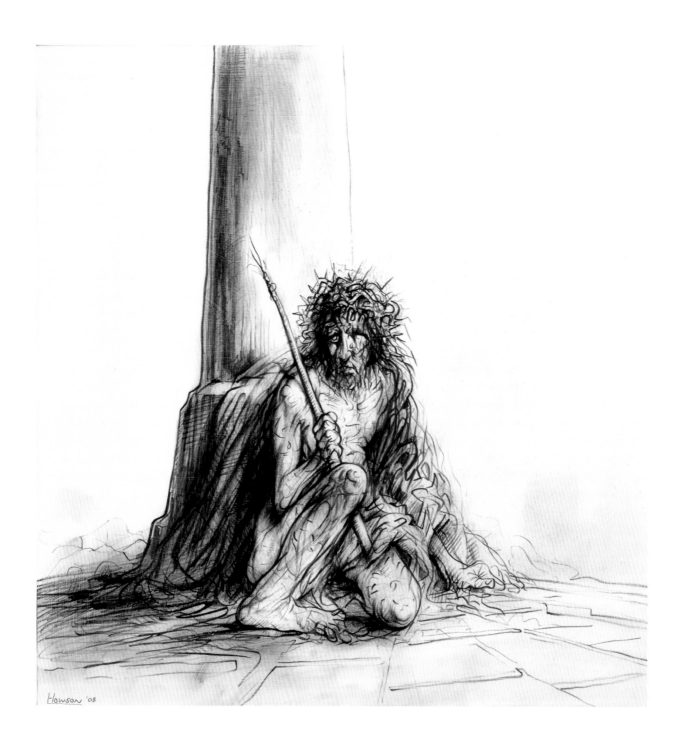

Howson '08

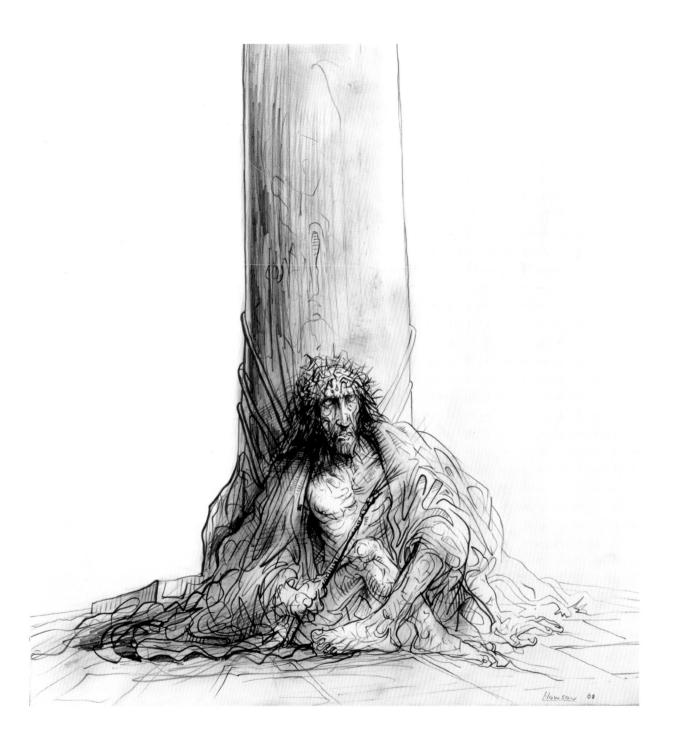

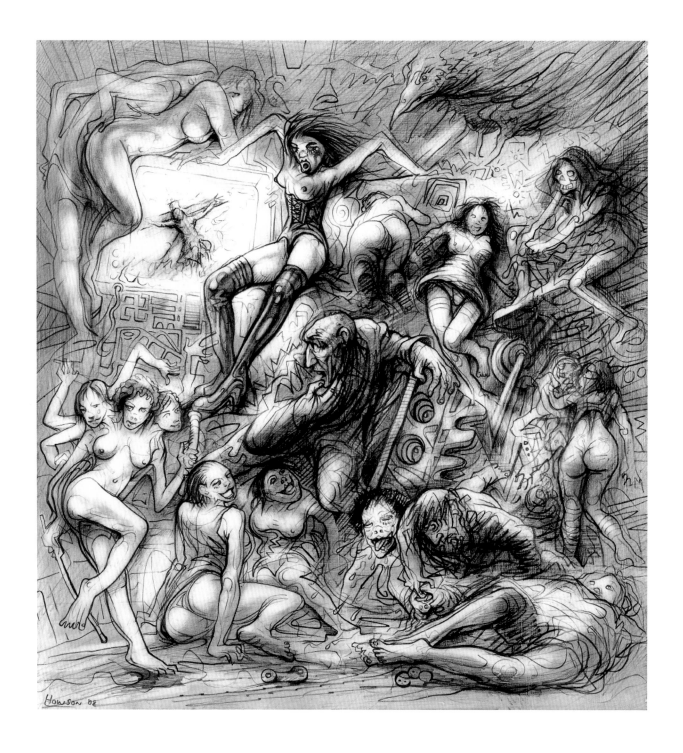

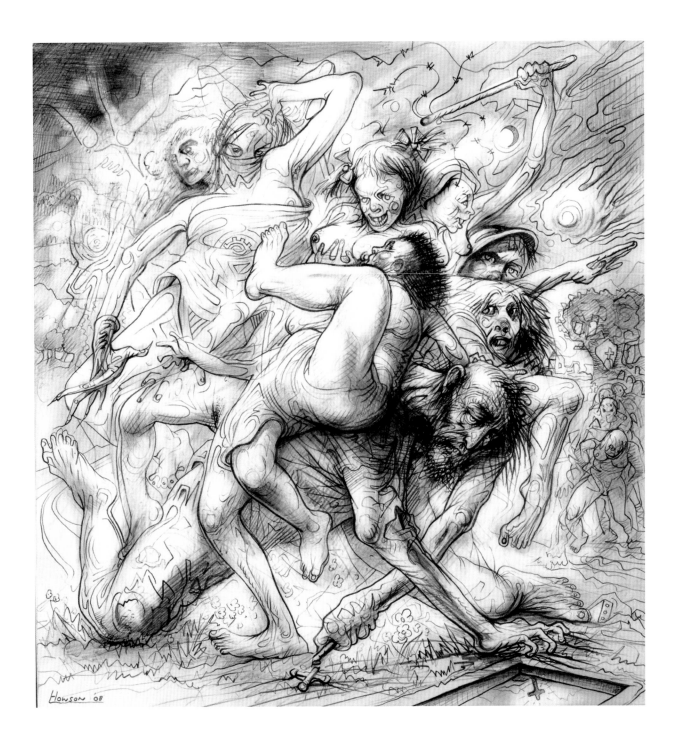

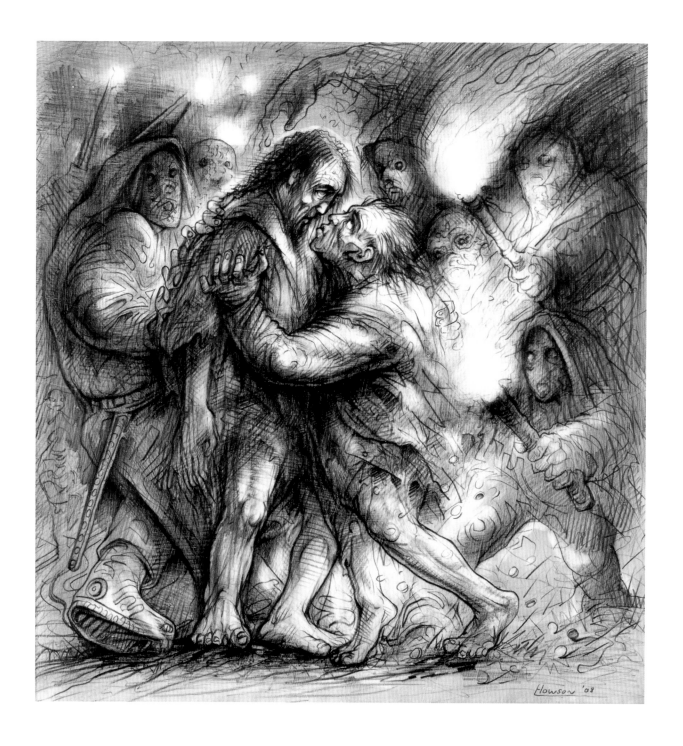

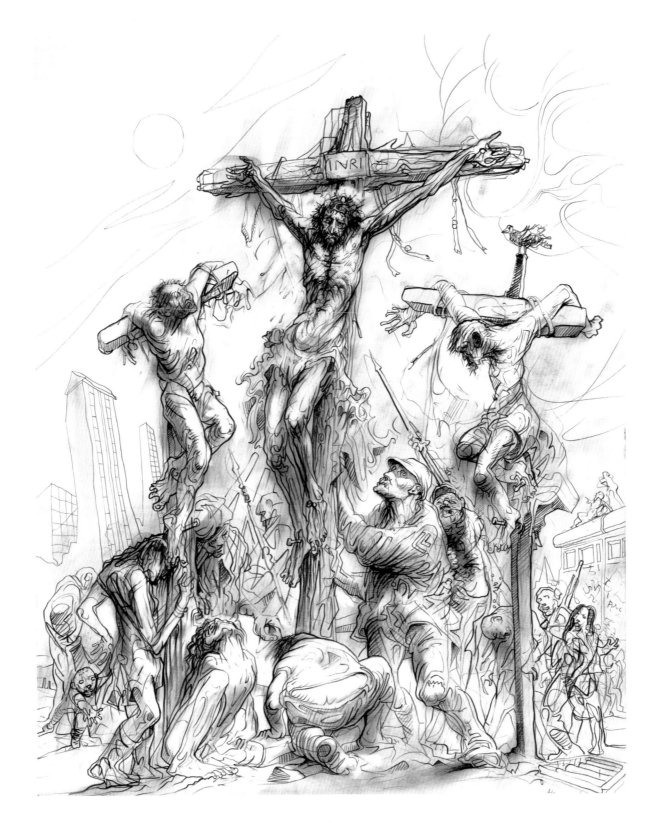

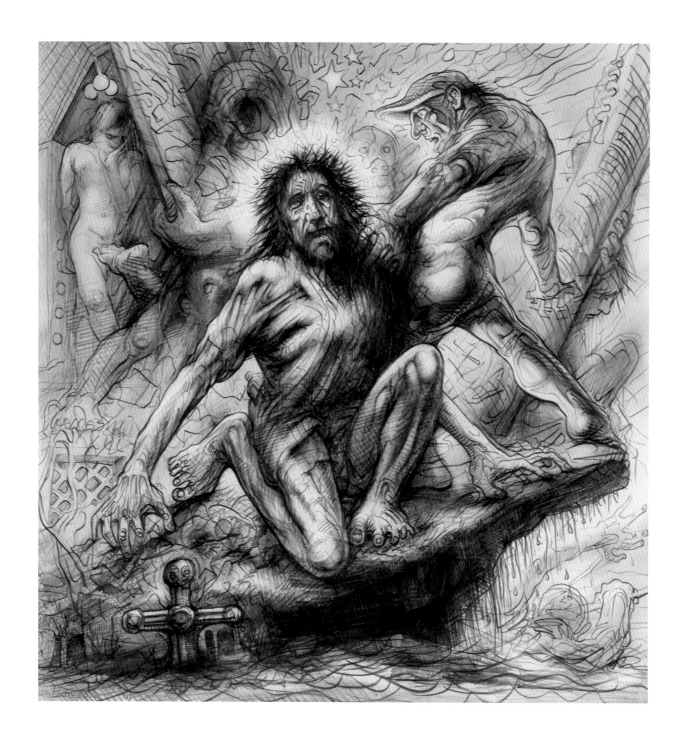

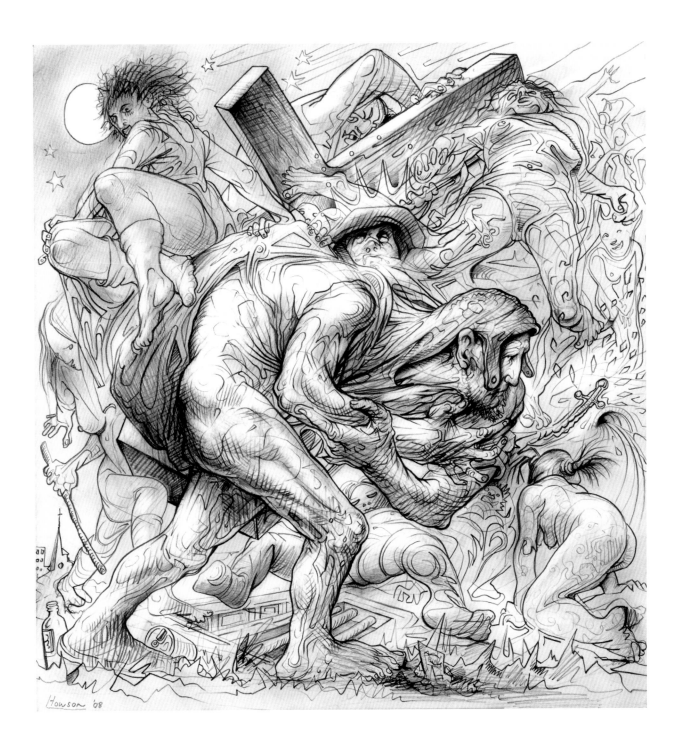

16

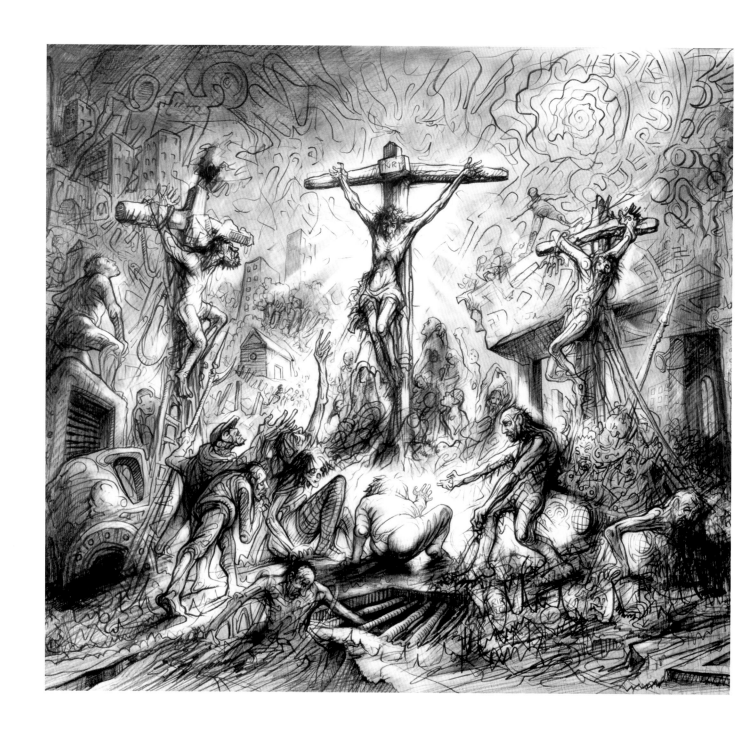

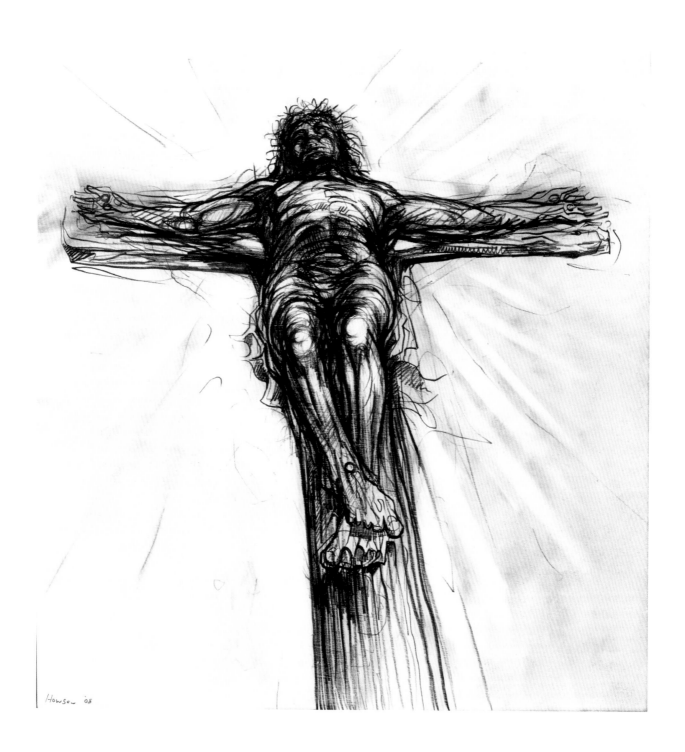

Howson '08

19

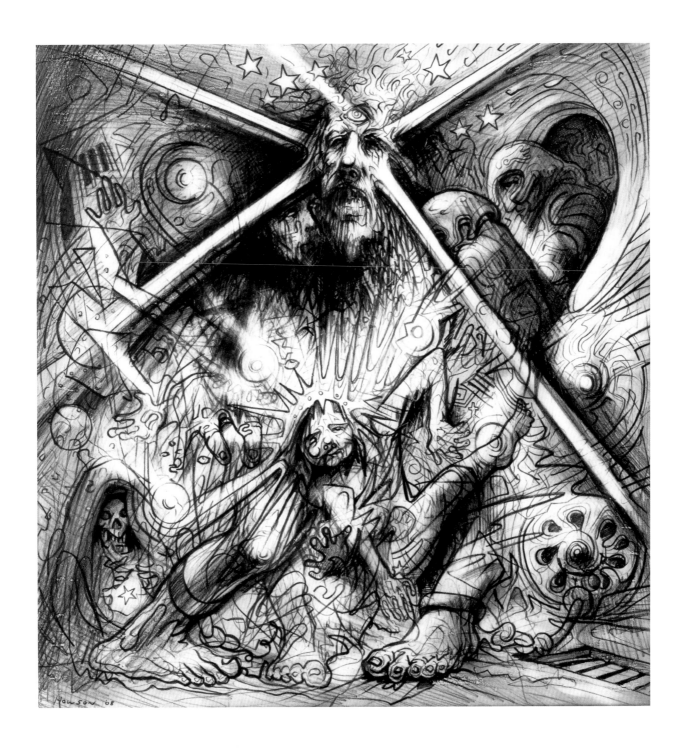

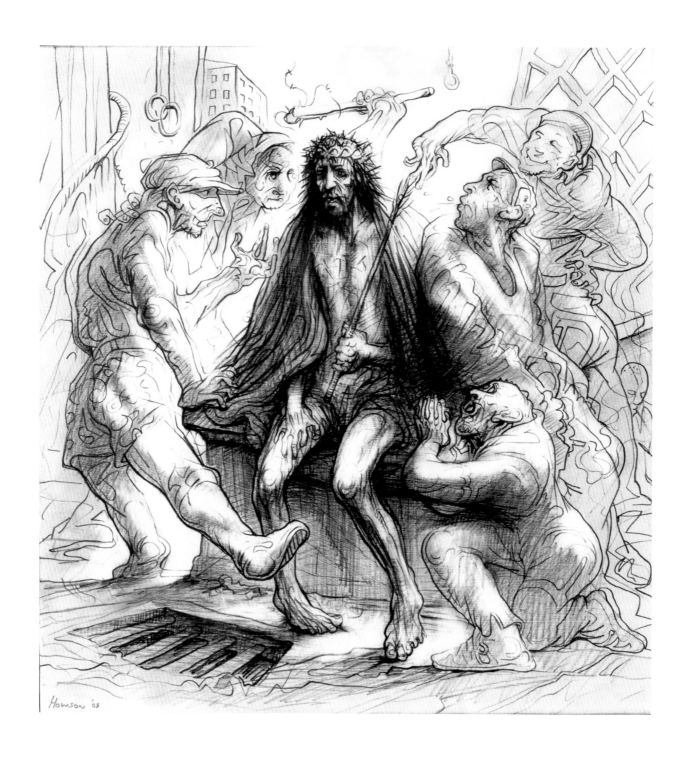

Howson '08

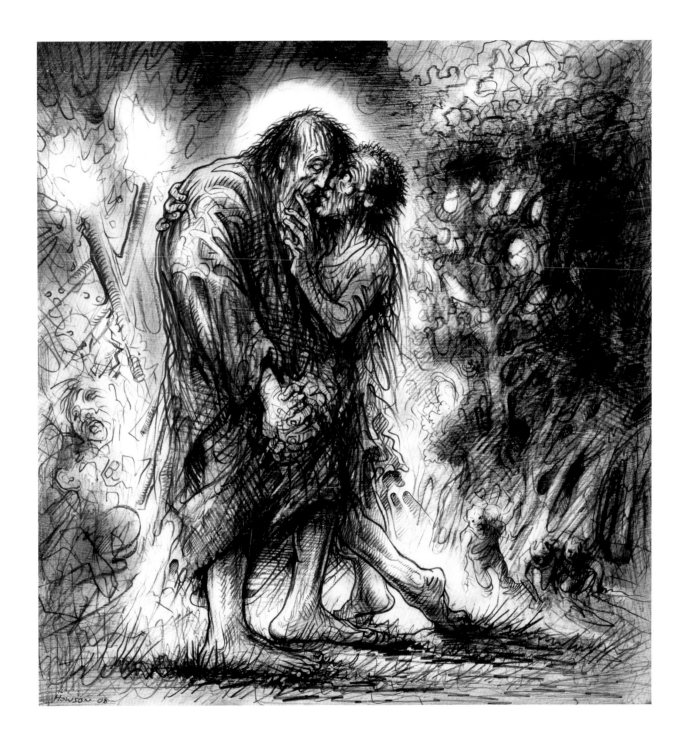

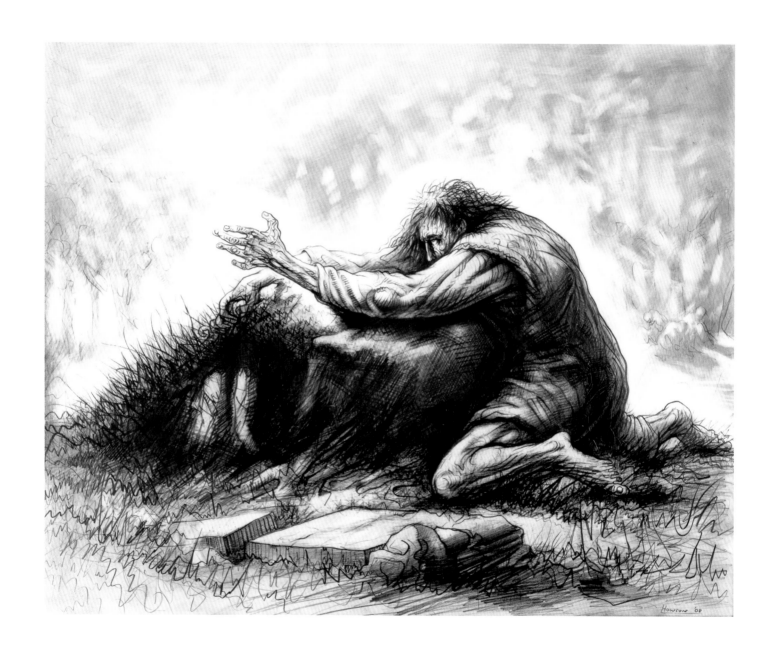

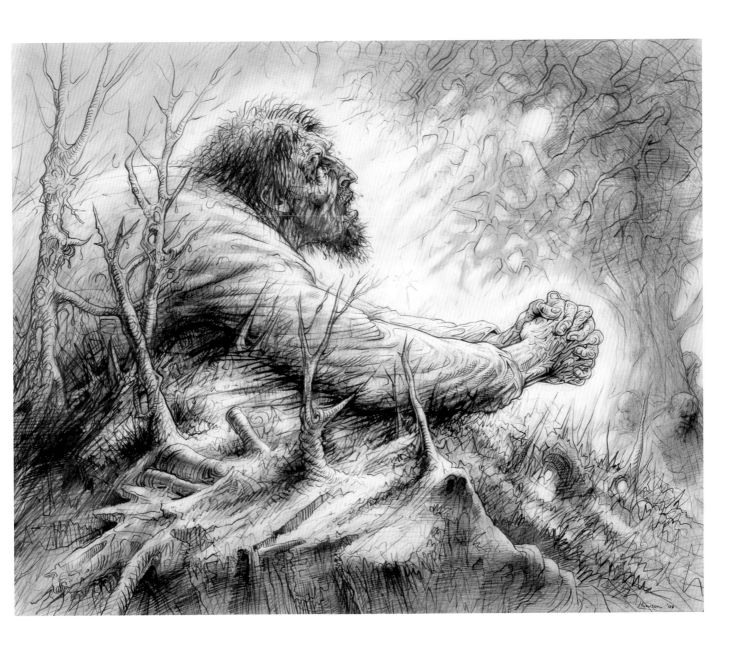

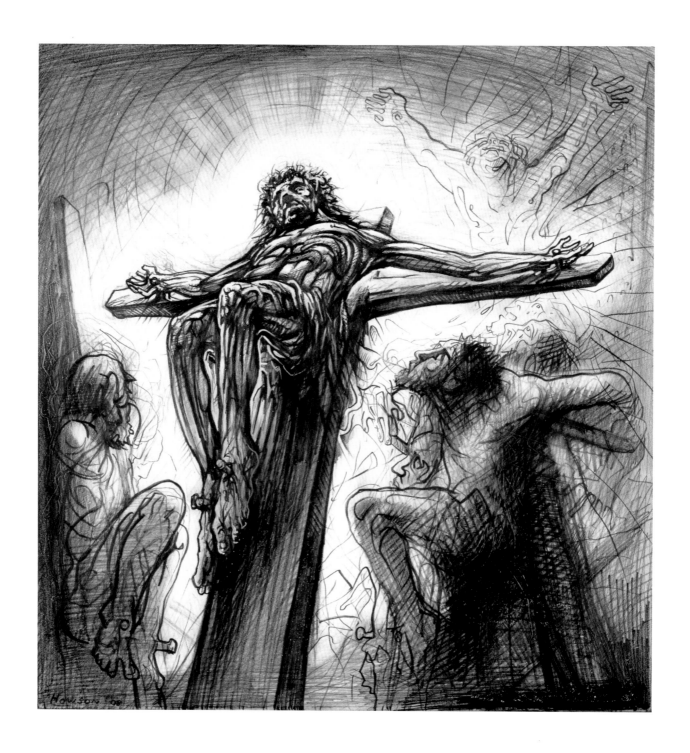

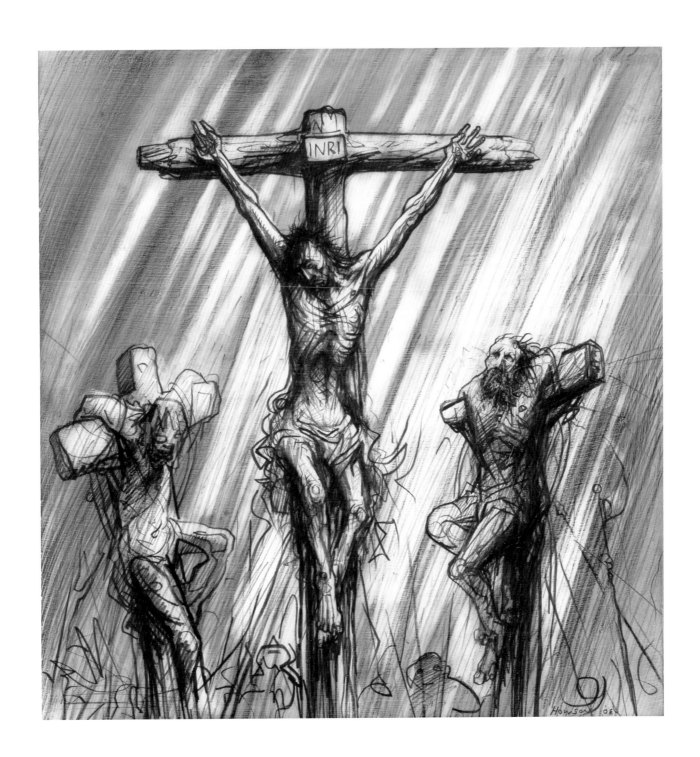

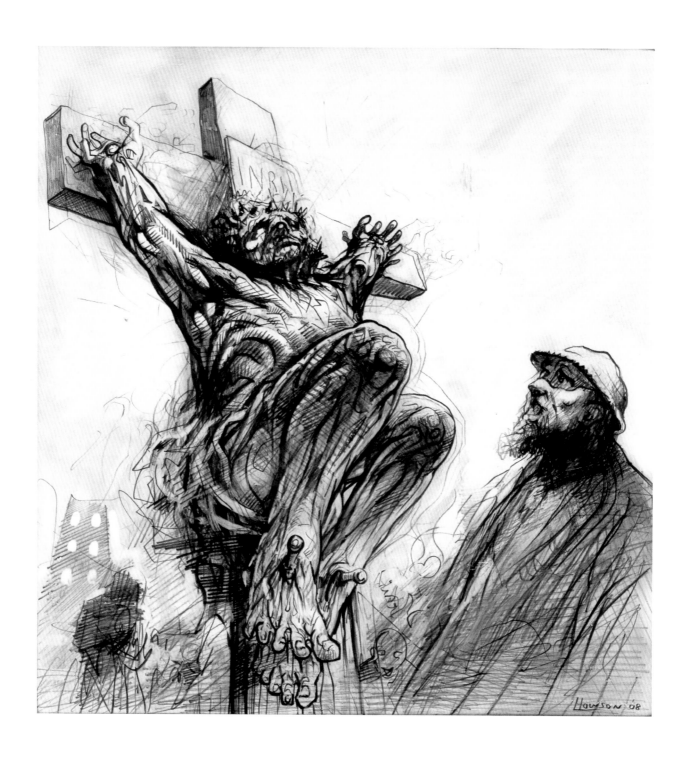

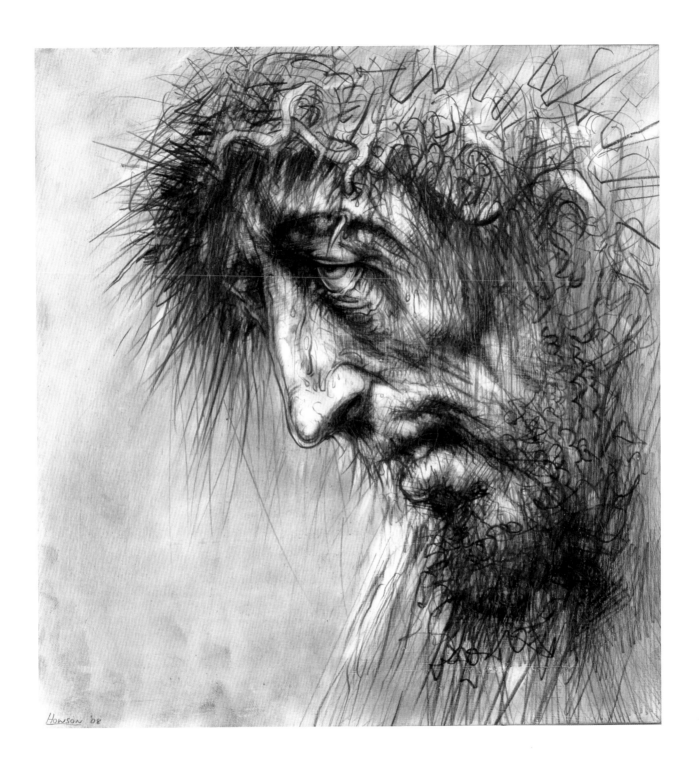

Howson '08

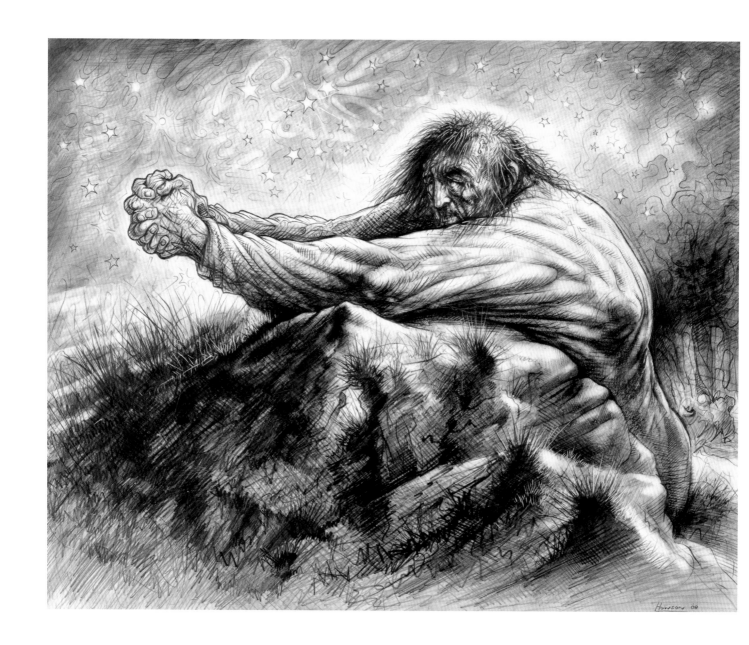

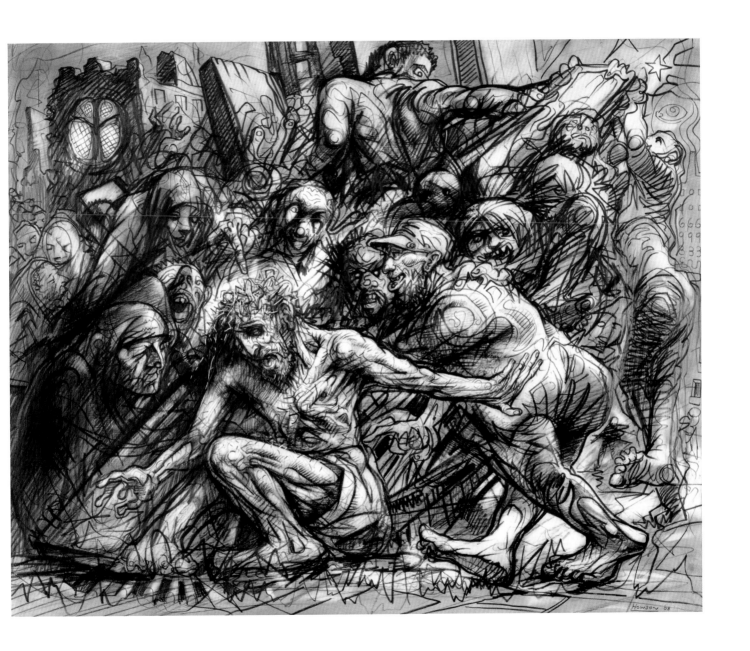

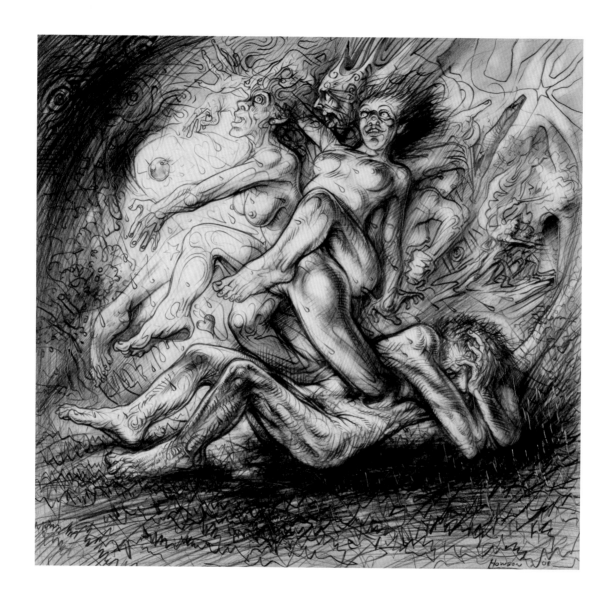

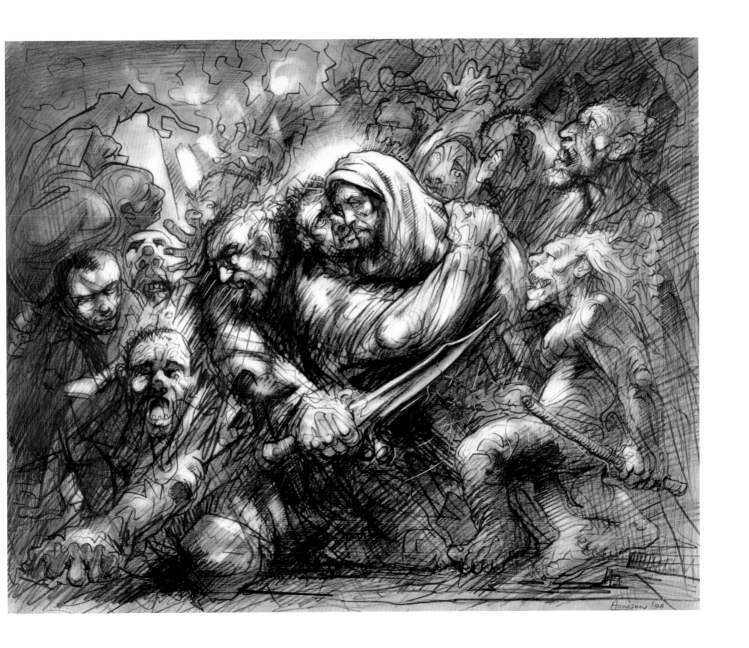

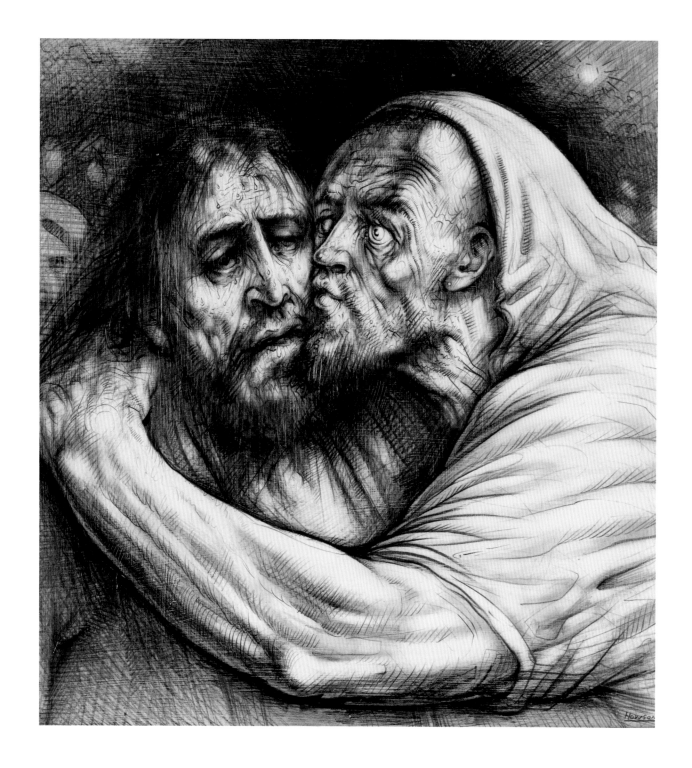

Plates

Paintings

1. Landlord's Castle 2008
184 x 243 cm

2. The Everlasting Man 2008
198.5 x 244 cm

3. Harrowing of Hell 2007
198.5 x 244 cm

4. City of Destruction 2008
199 x 244 cm

Pencil on gessoed oak panels

5. Despised, Crucified, Glorified 2008
38 x 30 cm

6. Abraham and Isaac 2008
21.5 x 21 cm

7. Eloi, Eloi 2008
21.5 x 21 cm

8. Holy Sickness 2008
21.5 x 21 cm

9. King of the Jews 2008
21.5 x 21 cm

10. King of Jews II 2008
21.5 x 21 cm

11. Pornopolis 2008
21.5 x 21 cm

12. Shadowlands 2008
21.5 x 21 cm

13. The Kiss 2008
21.5 x 21 cm

14. Imagine 2008
30 x 38 cm

15. Unman 2008
21.5 x 21 cm

16. Vanity Fair 2008
21.5 x 21 cm

17. Hayeh! 2008
30 x 38 cm

18. Nella Sua Voluntade 2008
21.5 x 21 cm

19. Eloi, Eloi, Lama Sabachthani 2008
21.5 x 21 cm

20. Homerus Caecus Fuisse Dicitur 2008
21.5 x 21 cm

21. Kings Couriers 2008
21.5 x 21 cm

22. The Hour has Come 2008
21.5 x 21 cm

23. All Things New 2008
30 x 38 cm

24. Glory 2008
30 x 38 cm

25. Thieves I 2008
21.5 x 21 cm

26. Thieves II 2008
23 x 22 cm

27. Centurion 2008
21.5 x 21 cm

28. By His Stripes 2008
23 x 22 cm

29. Thy Will be Done 2008
30 x 38 cm

30. The Blood Red Track 2008
30 x 38 cm

31. The Creation of Eve 2008
21.5 x 22 cm

32. A Traitor's Love 2008
30 x 38 cm

33. End of the Beginning 2008
21.5 x 22.5 cm

PETER HOWSON

1958	Born, London
1975-77	Glasgow School of Art
1979-81	Glasgow School of Art
1985	Artist in Residence, University of St Andrews, Fife, Scotland
	Part-time Tutor, Glasgow School of Art
1993	Appointed Official British War Artist for Bosnia
1995	Lord Provost's Medal, Glasgow
1996	Awarded Doctor of Letters Honoris Causa, University of Strathclyde, Glasgow

SCHOLARSHIPS AND PRIZES

1979	Hospitalfield Scholarship, Hospitalfield House, Abroath, Scotland
1986	Prize winner Scottish Drawing Competition, Paisley Art Galleries, Paisley, Scotland
	Arthur Andersen & Co. Purchase Prize, Mayfest, Glasgow
	Edwin Morgan Artists' Prize, Glasgow
1988	Henry Moore Foundation Prize
1992	Eastward Publication Prize, RGI, McLellan Galleries, Glasgow
	Nomination for Lord Provost Prize at RGI, McLellan Galleries, Glasgow
	European Young Artists Prize, Sofia, Bulgaria
1998	Lord Provost's Prize 1998, Glasgow

SOLO EXHIBITIONS

1983	Wall Murals, Feltham Community Association, London
1985	New Paintings and Drawings, Mayfest, Glasgow Print Studio
	New Paintings, Crawford Centre for the Arts, University of St Andrews, Fife, Scotland
1987	Washington Gallery, Glasgow
	Angela Flowers Gallery, London
1988	New Works on Paper, The Scottish Gallery, Edinburgh
	Small Works on Paper, The Scottish Gallery, Edinburgh
	Small Paintings and Works on Paper, Angela Flowers Gallery, London
	The Twilight Zone, Cleveland Gallery, Middlesborough and Quay Arts Centre, Isle of Wight
1989	Saracen Heads, Flowers Graphics, London
	Paintings and Drawings, Flowers East, London
	New Prints, Flowers Graphics, London
	Drawings, Tegnerforbundet, Oslo
1990	Drawings and Small Paintings, Agarte Arte Contemporanea, Rome
	Mayfest Exhibition, Glasgow Print Studio, Glasgow
	Los Angeles International Art Exposition, Los Angeles
1991	New Prints, Flowers Graphics, London
	New Paintings, Lannon Cole Gallery, Chicago
	The Blind Leading the Blind, Flowers East, London
	Recent Paintings and Drawings, The Maclaurin Gallery, Ayrshire, UK
1992	Galeria Estiarte, Madrid
1993	The Common Man, Flowers East at London Fields, London
	Peter Howson: A Retrospective, McLellan Galleries, Glasgow
	Peter Howson: The Lowland Heroes and other drawings, Angela Flowers Gallery, London
1994	Peter Howson: Bosnia, Imperial War Museum London and Flowers East, London
	Bosnian Harvest, Glasgow Print Studio, Glasgow
1996	*The Rake's Progress* and Other Paintings, Flowers East, London

	Drawings, Tegnerforbundet, The Drawing Art Association of Norway, Oslo
	Cabinet Paintings, Roger Billcliffe Fine Art, Glasgow
	Peter Howson, Drumcoon Arts Centre, Wigan, UK
1997	Peter Howson: New Works, Flowers East, London
	Djanogly Gallery, University of Nottingham, Nottingham
1998	Art Institute of Southern California, Los Angeles
	World Cup: Football Paintings, Gallery M, London
	Peter Howson, Flowers West, Los Angeles
	Football Paintings, Roger Billcliffe Fine Art, Glasgow
	New Paintings, Drawings and Prints, Flowers East, London
1999	Roger Billcliffe Fine Art, Glasgow
	Sex, War, and Religion, Flowers East, London
2000	Roger Billcliffe Fine Art, Glasgow
	Royal Glasgow Institute, Glasgow
2001	Peter Howson, Flowers West, Los Angeles
2002	The Third Step Maclaurin Gallery, Ayr, Scotland
	Flowers Central, London
2003	Stations of the Cross, Flowers East, London
2004	Inspired by the Bible, New College, Edinburgh
	Stations of the Cross, St Mary's Cathedral, Glasgow
2005	Christos Aneste, Flowers New York, New York
	New Howson Stock, Flowers East, London
2006	Peter Howson Retrospective, Kunstverein, Lingen, Germany
	The Last Supper, Carby Art Gallery, Aberdeen
2007	Andrew: Portrait of a Saint, City Art Centre, Edinburgh

SELECTED GROUP EXHIBITIONS

1981	Naked Nude, 369 Gallery, Edinburgh
1982	Pictures of Ourselves, Scottish Arts Council (touring exhibition)
1983	Three Scottish Artists, Maclaurin Art Gallery, South Ayrshire, Scotland
	Grease and Water: The Art & Technique of Lithography, Printmaker's Workshop, Edinburgh
1984	Winning Hearts and Minds, Transmission Gallery, Glasgow
1985	Scottish Drawing Exhibition, Paisley Art Gallery, Paisley, Scotland
	Networking, O'Kane Gallery, Houston, Texas
	New Image Glasgow, Third Eye Centre, Glasgow and Air Gallery, London (touring exhibition)
	Unique and Original, Glasgow Print Studio (touring exhibition)
	The Smith Biennial, The Smith Art Gallery and Museum, Stirling, Scotland
	Five Scottish Artists, Leinster Fine Art, London
1986	New Art from Scotland, Warwick Arts Trust, London
	New Work (with Stephen Barclay), Paton Gallery, London
	The Barras, Mayfest Exhibition, Compass Gallery, Glasgow
	The Eye of the Storm: Scottish Artists and the Nuclear Arms Debate, The Smith Art Gallery and Museum, Stirling, Scotland (touring exhibition)
	Scottish Art Today: Artists at Work 1986, Edinburgh International Festival Exhibition, Edinburgh College of Art, Edinburgh
1987	Scottish Contemporary Paintings, Turberville Smith, London
	Critical Realism, Nottingham Castle Museum and Art Gallery (touring exhibition), Nottingham
	The Vigorous Imagination, Scottish National Gallery of Modern Art, Edinburgh
	The Festival Folio, Edinburgh Print Workshop, Edinburgh

	Passage West, Angela Flowers (Ireland) Inc., Co. Cork
	Small is Beautiful V: Landscapes, Angela Flowers Gallery, London
1988	Eighty European Painters, touring exhibition
	Contemporary Portraits, Flowers East, London
	Figure II: Naked, Aberystwyth Arts Centre, Wales (touring exhibition)
	The New British Painting, Contemporary Arts Centre, Cincinnati and USA tour, 1988-90
	Small is Beautiful VI, Flowers East, London
1989	Big Paintings, Flowers East, London
	Confrontation: Three British Painters, Joy Emery Gallery, Grosse Point, Michigan
	Picturing People, Figurative Painting from Britain 1945-89, touring Kuala Lumpur, Hong Kong and Singapore
	4th International Young Artists Competition, Sofia, Bulgaria
1989/90	Angela Flowers Gallery 1970-1990, Barbican Concourse Gallery, London
1990	Flowers at Moos: Amanda Faulkner, Peter Howson, Lucy Jones, John Keane, John Kirby, Jonathan Waller, Gallery Moos, New York
	21 Years of Contemporary Art, Compass Gallery, Glasgow
	Mixed Scottish Exhibition, Beaux Arts, Bath
	Edinburgh Salutes Glasgow, The Scottish Gallery, Edinburgh
	Glasgow's Great British Art Exhibition, McLellan Galleries, Glasgow
	Old Museum of Transport, Glasgow
	Three Generations of Scottish Painters, Beaux Arts, Bath
	John Bellany, Peter Howson, Jock McFadyen, Pamela Auchincloss Gallery, New York
	UK British Culture Festival, Scottish Contemporary Art Exhibition, Keio Department Store, Tokyo (touring exhibition)
	Small is Beautiful VIII: The Figure, Flowers East, London
1991	Angela Flowers Gallery 1991, Flowers East, London
	The Boat Show, Smiths Galleries, London
	Inaugural Exhibition, Lannon Cole Gallery, Chicago
	Human, Suburban Fine Arts Center, Highland Park, Illinois
1992	Artist's Choice, Flowers East, London
	Portrait of the Artist's Mother done from Memory, Flowers East, London
	Small is Beautiful, X: Animals, Flowers East, London
	Figure in the City (touring exhibition), Talbot Rice Gallery, Edinburgh
	Mia Joosten Gallery, Amsterdam
	The New Civic Theatre Gallery, Maastricht
	Y'Art Gallery, Utrecht
	BP Gallery, Brussels
	Innocence and Experience (touring exhibition), Manchester City Art Gallery, Ferens Art Gallery, Hull
1993	Castle Museum, Nottingham
	McLellan Galleries, Glasgow
	Glasgow Print Studio, Glasgow
	Scottish Painters, Flowers East at London Fields, London
1994	New Work, Flowers East at London Fields, London
	Inner Visions, Flowers East at London Fields, London
1995	Message from Bosnia: Peter Howson and Iain McColl, The Dick Institute, Kilmarnock, Scotland and touring
	The Twenty Fifth Anniversary Exhibition, Flowers East at London Fields, London
	Flowers at Koplin, Koplin Gallery, Los Angeles
	Small is Beautiful XIII: Food and Drink, Flowers East, London
1996	Robert Burns Exhibition, Compass Gallery, Glasgow
	Gracefield Art Centre, Dumfries, Scotland
	Naked, Flowers East at London Fields, London
	Wheels on Fire, Cars in Art, 1950-1996, Wolverhampton Art Gallery, Wolverhampton, UK
	Four British Painters, John McEnroe Gallery, New York
	Angela Flowers Gallery (Ireland) Inc., Co. Cork
	Four British Painters, Mendenhall Gallery, California
	Masks, Prince of Wales Trust Auction, London
	Small is Beautiful, XIV: Sex, Flowers East, London
1997	Angela Flowers Gallery, Flowers East at London Fields, London
	Art et Guerre, Galerie Piltzer, Paris
	After the War was Over, Angela Flowers (Ireland) Inc. Co., Cork
	The Body Politic, Wolverhampton Art Gallery, Wolverhampton, UK
	Small is Beautiful XV: Death, Flowers East, London
	The Print Show, Flowers Graphics, London
1998	The Lord Provost's Prize, Gallery of Modern Art, Glasgow (First Prize winner)
	Royal Academy Summer Exhibition, Royal Academy of Arts, London
	Self Portrait, Six Chapel Row Gallery, Bath
	Angela Flowers Gallery at Riverside Studios, London
1999	Post Impressions, British Library, London
	Contemporary British Landscape, Flowers East, London
	Scotland's Art, Edinburgh City Art Centre, Edinburgh
2000	30th Anniversary Exhibition Flowers East, London
	Pastel Society, Mall Galleries, London
	Wild Tigers of Bandhavgarh, The Burrell Collection, Glasgow
	Labour Intensive: Howson and Herman, The City Gallery, Leicester
	Flowers II, Flowers Central, London
2001	12 British Figurative Painters, Flowers West, Los Angeles
	Small is Beautiful XIX: Still Life, Flowers East, London
2002	Flowers Eight, Flowers Central, London
2003	The New Glasgow Boys, The Fleming Collection, London
2004	Presence, St Pauls Cathedral, London
	Retrospective, Flowers Graphics, London
	Dreaming, Flowers East, London
	Spiritus Mundi, Flowers East, London
	Royal Academy Summer Exhibition 2004, London
	Contemporary Nudes, Flowers East, London
	Small Is Beautifull XXII, Flowers Central
2005	35th Anniversary Exhibition, Flowers East and Flowers Central, London
	Paintings from the 90's, Flowers Central, London
2007	The Apprentice, Spectrum, London
	John Lennon Northern Lights, Durness Sutherland, Scotland and London

PUBLIC COLLECTIONS

Aberdeen Art Gallery, Aberdeen
Bankfield Museum, Halifax
British Broadcasting Corporation
British Council
British Museum, London
Cartwright Hall, Isle of Man Arts Council, Bradford, Isle of Man
Kilmarnock and Loudoun District Museums, Scotland
Library of Congress, Washington DC
Lloyds TSB Group Plc, London
The Maclaurin Trust, Ayr, Scotland
Metropolitan Museum of Art, New York
Ministry of Defence, London
Museum of Modern Art, New York
National Gallery of Norway, Oslo
New York Library, New York
Nottingham Castle Museum and Art Gallery, Nottingham
Paisley Art Gallery, Paisley, Scotland
Paul Mellon Centre, Yale University, London
Peter Scott Gallery, Lancaster University, Lancaster, UK
Robert Fleming Merchant Bank, London
Royal Bank of Scotland
Scottish Amicable
Scottish Development Agency
The Arts Council of Great Britain
The Scottish Arts Council
The Scottish National Gallery of Modern Art, Edinburgh
Scottish Television (STV)
Tate Gallery, London
University College of Wales, Aberystwyth, Wales
University of Salt Lake City, Salt Lake City, Utah
University of Strathclyde, Glasgow
Victoria & Albert Museum, London
Walker Art Gallery, Liverpool
Christie's Corporate Collection, London
City Art Centre, Edinburgh
City Art Gallery, Southampton, UK
Contemporary Art Society, London
Dundee Art Gallery, Dundee, Scotland
Eigse Festival Collection, Carlow, Ireland
Fitzwilliam Museum, Cambridge
Glasgow Museums (Art Gallery and Museum, Kelvingrove)
Glasgow Royal Concert Hall
Gulbenkian Collection, Lisbon, Portugal
Hunterian Museum, Glasgow
Imperial War Museum, London

FLOWERS

82 Kingsland Road
London E2 8DP
Tel: +44 (0) 20 7920 7777
Fax: +44 (0) 20 7920 7770
gallery@flowerseast.com

21 Cork Street
London W1S 3LZ
Tel: +44 (0)20 7439 7766
Fax: +44 (0)20 7439 7733
central@flowerseast.com

1000 Madison Avenue
New York, NY 10075
Tel: +1 (212) 439 1700
Fax: +1 (212) 439 1525
newyork@flowerseast.com

www.flowerseast.com

Published on the occasion of the
exhibition
Peter Howson: Harrowing of Hell
24 October-22 November 2008
Flowers Kingsland Road, London

© 2008 Peter Howson, Robert Heller
and Flowers, London

Catalogue: Bishops Printers, Port-
smouth
Co-ordination: Carly Greene
1000 copies

ISBN 978-1-906412-19-7